Mona Hatoum

Domestic Disturbance

Mona Hatoum
Domestic Disturbance

Laura Steward Heon, *editor*

MASS MoCA, North Adams, Massachusetts

SITE Santa Fe, Santa Fe, New Mexico

This publication accompanies the exhibition *Mona Hatoum: Domestic Disturbance*, organized by MASS MoCA with SITE Santa Fe. It was presented at SITE Santa Fe from October 7, 2000 to January 14, 2001, and at MASS MoCA from March 18 to November 15, 2001.

Mona Hatoum: Domestic Disturbance would not be possible without the generous support of MASS MoCA's funders: the LEF Foundation; the Ellis L. Phillips Foundation; the Robert Lehman Foundation, Inc.; the Horace W. Goldsmith Foundation; the Massachusetts Cultural Council, a state agency; and the National Endowment for the Arts, a federal agency; as well as our faithful members and donors. The SITE Santa Fe presentation was made possible by major support from the Lannan Foundation, with additional support from the City of Santa Fe Arts Commission and the 1% Lodger's Tax.

Book design by Doug Bartow, MASS MoCA
Edited by Gwen Steege, Storey Publishing
Printed in Canada by Transcontinental-Interglobe
The cover was printed 4-color process at 200-lines direct to plate on Zanders Mother of Pearl Chromalux cover stock. The text was printed black + pms warm grey 6 direct to plate on 100# dull text stock. Principal typeface: Rotis San Serif.

MASS MoCA
87 Marshall Street
North Adams, Massachusetts 01247
PH 413.664.4481 FAX 413.663.8548
www.massmoca.org

Cover: Mona Hatoum, *Vicious Circle*, 1999
Courtesy of the artist and Alexander and Bonin, New York
Photo: Herbert Lotz

Distributed by Storey Publishing
105 Schoolhouse Road
Pownal, VT, 05261 PH 413.346.2100 FAX 413.346.2196
www.storeybooks.com

Table of Contents

6 Lenders to the Exhibition

7 Foreword, Louis Grachos, *Director and Curator SITE Santa Fe*

9 Boards of Directors, SITE Santa Fe and MASS MoCA

11 "Grist for the Mill," Laura Steward Heon, *Curator MASS MoCA*

19 Mona Hatoum interviewed by Janine Antoni

34 Color Plates

65 Mona Hatoum interviewed by Jo Glencross

71 Afterword, Joseph C. Thompson, *Director MASS MoCA*

72 Works in the Exhibition

74 Abbreviated *Curriculum Vitae*

Lenders to the Exhibition

Mona Hatoum, London

Alexander and Bonin, New York

Lenore and Rich Niles, San Francisco

Peggy and Ralph Burnet, Wayzata, Minnesota

Marc and Livia Straus Family, New York

Ted Bonin, New York

SITE Santa Fe and MASS MoCA are proud to present recent work by internationally renowned artist Mona Hatoum. Primarily completed in the past two years during residencies at ArtPace in San Antonio, Texas, and Le Creux de l'Enfer in Thiers, France, this eclectic collection of two- and three-dimensional work continues themes that have preoccupied Hatoum throughout her 20-year career. Ideologies that bind and direct our realities (in particular, ideologies that define gender roles and shape our relationships to our bodies) are examined in unique and disparate works that, more often than not, derive from the domestic realm. Familiar objects that typically seem benign are enlarged or reconfigured into starkly beautiful works that present a very real, or at least implied, threat: Electrified kitchen utensils are almost within reach; an egg slicer is large enough to cradle a newborn baby. However, in keeping with the times, which, since the mid-1990s, have seen a waning in the prevalence of art with blatant sociopolitical motivations, Hatoum favors nuance and poetic suggestion over didactic rhetoric. She never posits answers for her questions, nor directly identifies the subjects of her critiques. In fact, the complex mélange of ideas in a Hatoum piece, evoked solely by the physicality of the materials (steel, aluminum, plastic, wax paper, wood), implicates and victimizes the viewer in equal measure.

Hatoum's commitment to presenting us with this complex, if at times uncomfortable, perspective of lived experience continually reaffirms her significance as an artist and intellectual.

The success of this exhibition and publication is due in no small part to the efforts of several individuals. SITE Santa Fe thanks Joseph C. Thompson, Laura S. Heon, and the MASS MoCA staff for their hard work and initiative. The unique mandates of both SITE Santa Fe and MASS MoCA have led to a partnership that we look forward to continuing. Ted Bonin at Alexander and Bonin, New York, and Gerry Collins both helped immeasurably with this project. As always, I extend my deepest appreciation to the Board of Directors and staff at SITE Santa Fe, in particular Erin Shirreff, Associate Curator, and Craig Anderson, Head of Exhibitions Administration, for their unflagging dedication. I am grateful to the Lannan Foundation for its steadfast commitment to contemporary art, and to Rosina Lee Yue and Dr. Bert A. Lies and the Tesuque Art Book Fund for their continued support of SITE Santa Fe's publication program. Finally, I would like to thank Mona Hatoum with whom I have had the pleasure of working before, and who continually impresses me with her flexibility and generosity.

Louis Grachos
Director and Curator
SITE Santa Fe

Laura Steward Heon, *Curator MASS MoCA*

Mona Hatoum makes humble objects speak. She unleashes intense and arresting sensations in banal things — a cheese grater, a wine bottle, some gloves. These sensations send her viewers scrambling for meanings, which multiply and scatter before them. Like a detective, she knits together slender facts from mute, obdurate objects and reveals human comedies and tragedies unfolding. For this exhibition, she has turned her attention to objects from the home and objects from the factory. These objects share their quotidian origin in the recent past; they are for the most part not from a contemporary home or factory but from one of not so long ago, which is nevertheless impossible to date precisely. Their materials unite them, too — metal, mostly, with some wood, glass, leather, plastic. Such materials should make us feel right at home, but in Hatoum's hands they chill us and put us on guard.

The strength of Hatoum's work is in its restraint. To confront her work in a gallery is to meet so many sphinxes, silent, knowing, potent. This secretive silence, a product of restraint, links her work to the that of the Surrealists, as does her uncommon use of common materials. One of Hatoum's introductions to art came through the Surrealists, and the first art book she ever bought was about René Magritte. The Surrealists came to these practices through their contemporary Sigmund Freud. They were masters of applying Freudian notions of the way the unconscious and the conscious mind operated to works of art. They reveled in their neuroses (believing, with Freud, that human beings are neurotic by definition), sometimes creating inscrutable works tightly bounded by some personal fantasy, and other times portraying demons that haunt us all. Hatoum's work, like the best work of the Surrealists, gets to the core of the human condition with breathtaking economy of means. They and she use what Freud called *condensation*, a process we all know from dreams, in which many meanings become condensed in a simple object. Hatoum's cool economy of condensation and her precise use of materials and references make the works effective. At times, the works lead you down such dark mental pathways that you realize, or hope, that Hatoum must be joking.

Consider *La Grande Broyeuse (Mouli-Julienne x17)*. At 18 feet tall, this dark metal work, whose title translates roughly as "the big grinder," towers over everything in the gallery, commanding your attention like a merry, but compassionless, queen. The work is a replica of a Mouli-Julienne,

a hand-cranked food grater and grinder, enlarged 17 times. In her interview with Jo Glencross, Hatoum explains that the Mouli makes her think of an animal with three spindly legs and an outsized tail — perhaps a praying mantis or scorpion ready for combat. However, something more than its biomorphic qualities leads us to compare it to an animal: The *Broyeuse* has a latent animism. You don't want to turn your back on it for fear it might skitter over and grab you, shredding you with the same efficiency as your Cuisinart might shred a carrot. This animism is in part due to the great crank and the casual way the spare shredding and grinding disks are laid on the gallery floor; the clear potential for the *Broyeuse* to grind is palpable. This work, furthermore, is not alone in its animism: *Slicer* (an oversized egg slicer), *Chain* (a looped chain of gloves stitched together to form a belt), and *Sous Tension* (an installation of electrified metal kitchen utensils emitting a loud, pulsing, grating sound) share this quality. Even the delicate rubbings on Japanese wax paper seem both haunted and haunting. These works take us back to a childhood uncertainty about what is, or is not, alive, a tickling fear called the uncanny.

In Freud's essay of 1919, "*Das Unheimlich*" ("The Uncanny"), he is quite specific about what constitutes the uncanny. He begins with the word's etymology. "*Heimlich*," means "secretive," "home-like," "homey," something close to "cozy," which makes "*unheimlich*" the secret revealed, the un-cozy, or anti-cozy. As only Freud can, he argues convincingly that "cozy" and "uncanny" are quite closely linked and, further, that anything uncanny must once have been homey and familiar. Thus the uncanny, which fills us with chilling dread, is something very near and dear to us that has undergone a mysterious change. He then enumerates uncanny things, including sprouting multiple limbs, seeing your double, blindness, and animism — that is, an uncertainty as to whether or not a thing is alive. He reasons that because children are confused about what is alive and what is not, and because this confusion is superceded in adulthood by reality testing and experience, it is a fear that everyone has personally known. Think back to the days before you laid aside your dolls, but after you gave up the belief that they were as alive as the family dog. There was certainly a period of uncertainty. Were the dolls alive or dead? Kind or vicious? Even though you are quite certain that the *Broyeuse* is not alive, it nevertheless conjures up a very real fear you once had. It is this nagging, gut-level, familiar dread that emanates from the *Broyeuse*, *Slicer*, *Chain*, and *Sous Tension*.

The threat is obvious in these works: The *Broyeuse* will grate you, the *Slicer* will slice you like an egg, and *Sous Tension* will deliver a powerful electric shock. The *Broyeuse* and *Slicer* advertise their

threat with their scale, *Sous Tension* with its electric sound. *Sous Tension* consists of a stout wooden table with metal kitchen tools on top of it and spilling away from it on the floor. Most of these objects have perforations for skimming, grating, or straining, through which slowly pulsating lights may be seen. Electrical wires strewn haphazardly about the floor connect the objects to each other. The whole installation is behind an impromptu metal fence that protects the viewers from it, with good reason. The literal translation of the work's French title is "under tension," but the phrase actually means "electrified," and both meanings apply. The excruciating electric humming, crackling, grating noise is the actual sound, amplified by Hatoum, of the electric current passing through these objects. In this case, although not actually alive, Hatoum's work is "live" enough to be lethal.

Sous Tension shares with the *Broyeuse* and *Slicer* more than their animistic threat, which is, after all, so horrible as to be ludicrously comic. The threat these works convey has a definite common source: the kitchen, and since they are old, an old kitchen, one remembered from childhood. The *Broyeuse* is modeled on an object Hatoum found in her mother's kitchen, while she bought the model for the *Slicer* at a flea market 20 years ago. Such a terrifying kitchen if encountered in a dream would portend . . . what? An all-powerful and angry mother? Hatoum's beleaguered homeland, Palestine? An ambivalence toward notions of home or homeland? The fear of a life of domestic drudgery? The bitterness of a nurturer to the object of her nurturance?

Other works in this group support various of these hypotheses: The *Baalbek birdcage*, a cage the size of a prison cell, confirms a near-universal feminine dread of a confining domestic life. The scale and shape of the work refer both to the size of a cell at Alcatraz and to a large four-poster bed. *Wheelchair II*, uncomfortable to sit in and with knife blades for handles, speaks volumes about the passions that rage, often quietly, between the caregiver and the cared-for. This work reveals itself to the viewer in stages: First, you see that the metal chair must be uncomfortable, then you notice the wheels are too small for the sitter to turn (thus necessitating a helper), finally you look at the well-honed handles.

The most intriguing counterpoint to these restrained but threatening objects, however, is the series of rubbings that Hatoum began making while in residence at a Shaker community in Sabbathday Lake, Maine, and continued while visiting her mother in Lebanon. The small, white sheets are simple objects even for Hatoum: She laid Japanese wax paper over the surface of old kitchen implements (colander, grater, strainer)

that she found in the Shaker kitchen and rubbed them, picking up on the sheets the impressions of the perforations and outlines of the objects. These faint, ghostly impressions, white on a white sheet, are the whole work. In her interviews with both Jo Glencross and Janine Antoni, Hatoum describes the feeling of "settledness and warm domesticity" at the Shaker community, a "beautiful family-like feeling, which . . . activated all sorts of forgotten needs." These were sensations that contradicted Hatoum's nomadic existence (in transit between residencies and exhibitions around the world, distant from her homeland and family) and what Hatoum refers to as the "ambiguous relationship to the domestic" often visible in her work. The rubbings expressing these "forgotten needs" are gentle ghosts, delicate, nostalgic, and throbbing with longing for a domestic world that may exist only with the last seven Shakers to remain on earth, or may not exist at all. These works, like the *Broyeuse* and its companions, are also dreams, but dreams of pathos and loss, rather than cool threats. When the rubbings and sculptures are taken together, as they must be in this exhibition, a nuanced and conflicted picture emerges, which may actually encompass homeland, home, womanhood, mom.

Certainly these are feminine works, all concavities and rounded voids. And Freud and Magritte's contemporary Karl Jung tells us that the universal

and eternal symbol for woman is a vessel. But Hatoum presents gigantic, powerful, metal vessels armed with slicing disks, or absent, humble vessels whose ghostly marks appear in the rubbings. These works deny the possibility of speaking in generalities about the feminine. Instead, they seem to invoke one particular woman: mother. With their shifting emphasis on strength and tenderness, presence and absence, fear and nostalgia, these works offer a tribute to mother, disciplinarian and nurturer, engine of the home, ultimate source.

Magritte, Freud, and Jung are not the only early twentieth-century figures lurking, perplexed, around Hatoum's armed and absent vessels. Marcel Duchamp is present and accounted for as well. Two works — *La Grande Broyeuse* and *Vicious Circle* — nod to Duchamp, in particular to the *Bride Stripped Bare by her Bachelors, even,* also called the *Large Glass.* This work, a "delay in glass" as Duchamp referred to it, is one of the most complex of the last century, but basically it is an elaborate sex machine. In the upper half is a virgin/bride who resembles a drive shaft, and in the lower half is the "Bachelor Machine," resembling a group of chess pieces arranged on a wheel, where the onanistic bachelors await their bride, forever unfulfilled. This "Bachelor Machine" is (metaphorically) powered by a "Glider," which is powered by a "Broyeuse au Chocolat," the namesake

of Hatoum's *La Grande Broyeuse*. There are several versions of the chocolate grinder in Duchamp's oeuvre. All derive from, among other things, a French saying — "the bachelor grinds his chocolate by himself" — doubtless a reference to masturbation and the clear reason why the "Broyeuse au Chocolat" powers the "Bachelor Machine." The question that poses itself, then, is: Why has Hatoum chosen Duchamp's "Broyeuse" as the godparent of her own? Her armed Jungian vessel, this merry, compassionless queen, must also be an auto-erotic sex machine, a *vagina dentata* of first order. Duchamp, Magritte, Freud, and Jung would be so pleased.

Hatoum's *Vicious Circle*, made in a local bottle factory in Thiers, France, is a group of ordinary green wine bottles laid in an unbroken circle on the floor, the neck of one inserted into the concave bottom of the next, in a restrained but impressive sex act. Its title coincides with a note in Duchamp's working plans for the construction of the *Large Glass*. Writing about the "Bachelor Machine," he lays out the "litanies of the Chariot,"

Marcel Duchamp, *The Bride Stripped Bare by Her Bachelors, even (The Large Glass)*, 1915–23

Philadelphia Museum of Art: Bequest of Katherine S. Dreier.

©2001 Artists Rights Society (ARS), New York/ADAGP, Paris/Estate of Marcel Duchamp

which is powered by the "Chocolate Grinder," and in turn turns the bachelors: "Slow life/ Vicious circle/ Onanism/ Horizontal/ Buffer of life/ Bach[elors] life regarded as an alternating rebounding on this buffer/ [. . .]." The note continues, describing the slow, methodical movement of the "Bachelor Machine," which, like Hatoum's bottles, in reality does not move at all.

Hatoum is fond of artist's residencies. She claims to think better when she is on the move, away from home, rather than staring at a white wall in her studio. Often the location of these residencies plays a role in the look of the work made there. Several of the works in this exhibition were made during a 1999 residency at Le Creux de l'Enfer, a former knife factory in Thiers, in the heart of industrial France, and a center for knife-making for hundreds of years. The slicing blades of Thiers made their way into *La Grande Broyeuse* and *Balançoires en fer* (a pair of metal swings that hang directly opposite each other and work like a horizontal guillotine), and were presaged in *Do unto others . . .* , a boomerang with a sharp blade

all around it made in 1996, as well as *wheelchair* and *wheelchair II*, made in 1998-99. Hatoum describes her vision of Thiers, and of Le Creux de l'Enfer, in particular, as a place with spinning wheels everywhere driving the machinery in the factory, grinding the knife blades until it all "finally ground to a halt," while the indifferent water that powered the machines kept on flowing.

Hatoum conjures these images of wheels and water in *Chain* and *Vidéau*. A large, wooden wheel, used to turn a long-gone belt, now serves as the hub of *Chain*. It supports a continuous "chain" of light-colored leather work gloves, sewn finger to finger and cuff to cuff, emblems of the generations of people working with their hands, not only at Le Creux de l'Enfer, but also wherever objects are made. The gloves are ghost hands, markers of absence, like the rubbings of implements in the Shakers' kitchen.

MASS MoCA is a particularly well-suited venue for Le Creux de l'Enfer works because it, too, is a former industrial site. In the gallery where Hatoum's works are installed, there are traces of the absent generations of workers in long-ago bricked-in windows and metal loading-dock doors that open into nothing. *Vidéau*, like *Chain*, speaks specifically about the history of Le Creux de l'Enfer, as well as generally about mill buildings everywhere. Hatoum filmed this silent, meditative video of rushing water in Thiers and slowed it so dramatically that it is difficult to tell whether what you see is water, steam, fire, or smoke. The inclusion of this video at MASS MoCA deliberately invokes the museum's physical location on a peninsula between two rivers, a location chosen more than 200 years ago for the water power the rivers provided for industrial development. The silent, inscrutable moving water metaphorically drives all the wheels and disks of this body of work.

During her brief time at MASS MoCA in the winter of 2000, Hatoum began work on a group of new sculptures made from several pairs of the hundreds of metal workers' chairs that can be found throughout the MASS MoCA campus. In these sculptures, one chair is stacked on another, seat to seat, and they are permanently sewn together with metal wire through perforations in the seats. The holes form letters that make up words invoking the fate of the departed workers. The new works are good companions to the still *Chain* of absent hands and the silent ghost river of Le Creux de l'Enfer.

Assisted ready-mades, such as the new chair works, appear frequently in Hatoum's work. An *assisted ready-made* is an everyday object altered in some way to make a work of art. In this exhibition, Hatoum used this technique in *Vicious Circle*, *No way, No way III, Chain, Sous Tension*, and the

chairs. In a long tradition originated by Duchamp and wonderfully exploited by the Surrealists, everyday objects are altered and a "new idea," to paraphrase Duchamp, is created for them. Most assisted ready-mades involve visual puns. An example is Duchamp's infamous *Fountain*, a urinal that he "assisted" by turning it upside down. The Surrealists delighted in bringing incongruous items together. Meret Oppenheim's fur-lined teacup may be the most famous example. Hatoum's assisted ready-mades surpass puns and incongruities and become engines for meaning. In *No way* and *No way III*, she assists an everyday strainer *(No way)* and colander *(No way III)* by plugging all their holes with metal bolts that stick out on the convex exteriors. There is *no way* these things could function as intended. The strainer looks like a mace; the colander takes on the appearance of a land mine. In these works, tangled political and psychological threads can begin to be unknotted. The inspiration for them came to Hatoum from roads blocked by military police in the Middle East; *no way* through here, so pass somewhere else. But in the context of the other works in this exhibition, they become a refusal to accept a domestic role, the impossibility of nurturance, the desire not to be merely functional. This last quality crosses over into the factory works, where the functionality of human beings (seen in the gloves sewn shut and the chairs that cannot be sat upon) is denied.

There is a connection between Hatoum's many residencies and her use of the assisted ready-made. In strange places, the most commonplace household tools take on an exotic aspect and can be examined divorced from their use value. Hatoum's proclivity to intensify the strange in the familiar, the uncanny in the homey, courses throughout her work, whether made in the studio or at residencies. This unusual pairing up of the strange with the familiar is always coupled with a visual paring down that somehow engenders a multiplication, rather than a reduction, of meanings. The origin of Hatoum's singular ability to combine these elements — the uncanny in the homey, multiple meanings from restraint — may be found, again . . . where? The use of residencies and ready-mades? Permanent exile? A deep understanding of the processes of the subconscious? Hatoum, as eloquent as a sphinx, replies only in her work, with little pieces of nothing that say everything, silently.

New York, Spring 1998

I met Mona Hatoum in December 1994 when we were installing our work, side by side, at the Reina Sofia in Madrid. The exhibition was called *Cocido y Crudo*, "The Raw and the Cooked." Mona was showing *Corps étranger*, a video made with a medical camera that had been threaded in and out of her orifices and along her body's surface. I was showing *Slumber*, a performance where at night I slept in the museum gallery, and in the day I weaved, from strips of my nightgown, the pattern of my rapid eye movements into an endless blanket.

The Reina Sofia, a former hospital, was a beautiful and scary place. Each night in the old building I could hear many sounds — as if the spirits were wandering around its long halls. Even the guards who passed through my room every hour told me they were afraid of a ghost named Ataulfo. It was not easy to sleep. And every morning at six o'clock I would jump out of my skin, waking to the lights and sound of Mona's video automatically turning on.

Since then, Mona and I have often appeared side by side, in many exhibitions. Most recently, we spent a month together at the only active Shaker community, in Sabbathday Lake, Maine. This is where I finally got close to Mona, but I felt I knew her way back in Spain when all day long I weaved while listening to the pulse of her body.

Mona Hatoum: I dislike interviews. I'm often asked the same question: What in your work comes from your own culture? As if I have a recipe and I can actually isolate the Arab ingredient, the woman ingredient, the Palestinian ingredient. People often expect tidy definitions of otherness, as if identity is something fixed and easily definable.

Janine Antoni: Do you think those kinds of questions have made us overly self-conscious about how we represent ourselves and its effect on the work?

MH: Yes, if you come from an embattled background, there is often an expectation that your work should somehow articulate the struggle or represent the voice of the people. That's a tall order, really. I find myself often wanting to contradict those expectations.

JA: Everyone seems eager to define you. When I was looking at your catalog and the articles written about you, I was struck by a certain consistency. Three articles started as follows:

"Lebanese-born artist, Mona Hatoum"; "Hatoum was born into a family of Palestinian refugees"; "Mona Hatoum is a woman, a Palestinian, a native of Beirut . . ."

MH: It's more the inconsistencies that bother me, like when people refer to me as Lebanese when I am not. Although I was born in Lebanon, my family is Palestinian. And like the majority of Palestinians who became exiles in Lebanon after 1948, my parents were never able to obtain Lebanese identity cards. It was one way of discouraging them from integrating into the Lebanese situation. Instead, and for reasons that I won't go into, my family became naturalized British, so I've had a British passport since I was born. I grew up in Beirut in a family that had

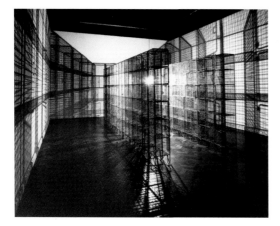

Light Sentence, 1992
Wire mesh lockers, motorized lightbulb, 78" x 73" x 193"
Collection of the National Gallery of Canada, Ottawa
Photo: Edward Woodman, Installation at Chapter, Cardiff

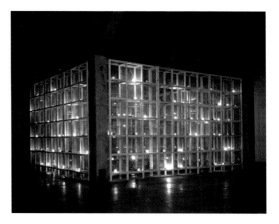

Current Disturbance, 1999
Wood, wire mesh, light bulbs, computerized dimmer switch, amplifier, four speakers; 110" x 216.5" x 198.5"
Collection of the Israel Museum, Jerusalem
Photo: Ben Blackwell, Installation at Capp Street Project, San Francisco

suffered a tremendous loss and existed with a sense of dislocation.

When I went to London in 1975 for what was meant to be a brief visit, I got stranded there because the war broke out in Lebanon, and that created another kind of dislocation. How that manifests itself in my work is a sense of disjunction. For instance, in a work like *Light Sentence* the movement of the lightbulb causes the shadows of the wire-mesh lockers to be in perpetual motion, which creates a very unsettling feeling. When you enter the space, you have the impression that the whole room is swaying, and you have the disturbing feeling that the ground is shifting under your feet. This is an environment in

constant flux — no single point of view, no solid frame of reference. There is a sense of instability and restlessness in the work. This is the way in which the work is informed by my background.

On the other hand, I have now spent half of my life living in the West, so when I speak of works like *Light Sentence*, *Quarters*, and *Current Disturbance* as making a reference to some kind of institutional violence, I am speaking of encountering architectural and institutional structures in Western urban environments that are about the regimentation of individuals, fixing them in space and putting them under surveillance. What I am trying to say here is that the concerns in my work are as much about the facts of my origins as they are a reflection on, or an insight into, the Western institutional and power structures I have found myself existing in for the last twenty-odd years.

JA: What makes one claim one history and not another? I am from the Bahamas but was educated in the U.S. as you were in London. Isn't Minimalism as much a part of our history as where we are from?

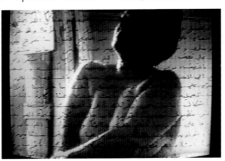

Measures of Distance, 1988
15-minute video
A Western Front video production, Vancouver

MH: Precisely. I was completely taken in by Minimal and Conceptual Art when I was on my first degree course. Going to University afterward, which was my first encounter with a large bureaucratic institution, I became involved in analyzing power structures, first in relation to feminism, and then in wider terms as in the relationship between the Third World and the West. This led me to making confrontational, issue-based performance works that were fueled by anger and a sense of urgency. Later, when I got into the area of installation and object making, I wouldn't say I went back to a minimal aesthetic as such. It was more a kind of reductive approach, if you like, where the forms can be seen as abstract aesthetic structures, but can also be recognized as cages, lockers, chairs, beds …The work therefore becomes full of associations and meaning — a reflection on the social environment we inhabit. Unlike minimal objects, they are not self-referential.

JA: In the show at the New Museum I was struck by the difference between the formal aspects of your later sculptures and an earlier piece like *Measures of Distance*. It is a piece that has

haunted me ever since I saw it a couple of years ago. This work is very personal, yet its form is illusive. You can't quite get at it. Visually, you are looking through layers of information: first, the handwritten letters in Arabic and, finally, the figure of your mother; you never quite see the nude image of your mother clearly. The sound works in the same way. I felt like I was straining to eavesdrop on a private conversation. The video doesn't have the direct quality that those later pieces have.

MH: Yes, *Measures of Distance* is quite a significant work for me. I see it as the culmination and conclusion of all the early narrative and issue-based work. For years I was trying to make general and objective statements about the state of the world. With *Measures of Distance* I made a conscious decision to delve into the personal — however complex, confused, and contradictory the material I was dealing with was. During a visit to Beirut in 1981, I took a dozen slides of my mother taking a shower. At the time, feminism had so problematized the issue of representation of women that images of women vacated the frame; they became absent. It was quite depressing. For a few years I agonized over whether I should use these images of my mother in my work. I didn't make the work in its final

form until 1988, but in between I used the material in a performance work. Anyway, once I made the work I found that it spoke of the complexities of exile, displacement, the sense of loss and separation caused by war. In other words, it contextualized the image, or this person "my mother," within a social-political context.

JA: I can relate to your battle about whether to work with those images of your mother, because I had similar questions when I started to work with my parents. I suddenly realized that my baggage had somehow come from them and to work with them meant asking them to confront these issues. At a certain point I had to ask myself whether it was my right to ask this of them and to expose them in this way. I was wondering whether the fogginess of *Measures of Distance* reflects a kind of ambivalence about exposing something quite intimate about your relationship with your mother — as well as an attempt to express the complexity by not allowing it to settle down anywhere.

MH: Yes, sort of wading through a mess of meaning.

JA: Which you do so beautifully, visually.

MH: Well, I wanted to explore the complexities through the juxtaposition of several formal and visual elements that create paradoxical layers of meaning. I wanted every frame to speak of both closeness and distance. You have the close-up images of my mother's naked body, which echo the intimacy of the exchange between us. These are overlaid by her letters, which are supposed to be a means of communication, yet at the same time, they prevent complete access to the image. People saw the Arabic writing as barbed wire.

JA: Or a veil.

MH: That's right. I structured the work around my mother's letters, because letters imply distance yet they are dealing with very intimate questions. And you've got our animated voices speaking in Arabic and laughing, which is contradicted by the sadness of my voice reading my mother's letters, translated into English.

JA: I love the way your questions are very confrontational, and yet she keeps saying, "My dear Mona, the love of my heart."

MH: Right, she uses even more flowery expressions that have no equivalent in the English language. When I made *Measures of Distance*, it felt like I had unloaded a burden off my back. I felt afterward that I could get on with other kinds of work, where every work did not necessarily have to tell the whole story, where I could just deal with one little aspect of my experience. That's when I started making installation work.

JA: If we look at your body of work at the New Museum, the later work becomes much more open. The political is there, but it has changed forms. Rather than being topical, it is experimental. Especially in the installations where the viewers find themselves in an uncomfortable position — from a position of instability, their response seems to yield the meaning.

MH: In the early performance work I was, in a sense, demonstrating or delivering a message to the viewer. With the installation work, I wanted to implicate the viewer in a phenomenological situation in which the experience is more physical and direct. I wanted the visual aspect of the work to engage the viewer in a physical, sensual, maybe even emotional way; the associations and search for meaning come after that. And although the title might direct your attention to one aspect of the work, I hope the work remains open enough to allow different interpretations. A woman here at the New Museum said that the lightbulbs fading

on and off in *Current Disturbance* made her think of a sexual orgasm. How beautiful! But, she said, then she remembered that my work is supposed to be political and had to think about the lights in the cages as representing people in prison. So I think that's a very good example. There is no single interpretation, which is why I always find it problematic when museums and galleries want to put up an explanatory text on the wall. It fixes the meaning and limits the reading of the work and doesn't allow viewers to have this very expansive imaginative interpretation of their own that reflects on their experience.

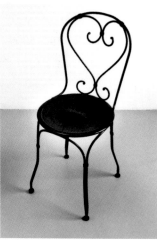

Jardin Public, 1993
Wrought iron, wax, pubic hair
34.25" x 17.33" (diameter)
Photo: Edward Woodman

JA: What role do you want your art to play, and what role do you feel the art world has cast you in?

MH: I want the work in the first instance to have a strong formal presence, and through the physical experience to activate a psychological and emotional response. In a very general sense I want to create a situation where reality itself becomes a questionable point. Where viewers have to reassess their assumptions and their relationship to things around them. A kind of self-examination and an examination of the power structures that control us: Am I the jailed or the jailer? The oppressed or the oppressor? or both? I want the work to complicate these positions and offer an ambiguity and ambivalence rather than concrete and sure answers. An object from a distance might look like a carpet made out of lush velvet, but when you approach it you realize it's made out of stainless steel pins, which turns it into a threatening and cold object rather than an inviting one. It's not what it promises to be. So it makes you question the solidity of the ground you walk on, which is also the basis on which your attitudes and beliefs lie. When my work shifted from the obviously political, rhetorical attitude into one bringing political ideas to bear through the formal and the aesthetic, the work became more of an open system. Since then I have been resisting attempts by institutions to fix the meaning in my work by wanting to include it in very narrowly defined theme shows.

JA: Well, in this climate of political correctness, people really don't know what to do with you if you don't fulfill certain stereotypes. Do you think that has pushed us, as artists, into making work

that refuses to be defined in that way? That it is a natural response to shy away from reinforcing the stereotypes? Knowing it's much more complicated than that.

MH: I've always had quite a rebellious and contrary attitude. The more I feel I am being pushed into a mold, the more I feel like going in the opposite direction. Like when I made a work called *Jardin Public*. I discovered that etymologically the words "public" and "pubic" come from the same source. I used a wrought-iron chair similar to those you see in public gardens in Paris — I gave it a French title to emphasize this association. And I implanted pubic hair in a triangular shape on the seat, like grass growing out of the holes. I enjoyed the surreal aspect of this work. By the way, my point of entry into the art world was through Surrealism — in fact, the first art book I ever bought was on Magritte. So this work was quite humorous and light-hearted; but at the same time you could read it as a comment on the fact that women's genitalia are always on public display. A number of people were surprised by this work. I realized that people didn't expect to see humor in my work.

JA: When you were talking about people wanting you to speak from the margins, as an outsider, as the other, it reminded me of the artist Felix Gonzalez-Torres trying to locate himself at the center. He took a form that was recognizably art, in the high art sense of the word, and slid his content underneath or inside of this form. People would accept his pieces initially and then have to deal with what they were really about.

MH: With the early performances, I saw myself as a marginal person intervening from within the margins of the art world, and it seemed logical to use performance as a critique of the establishment. After a while I was becoming dissatisfied with the obviously rhetorical attitude, and I wasn't sure any more whether the work I was doing was really what I wanted to do or the result of internalizing other people's expectations and the fact that I had been molded in the role of political artist. It's quite a thin line. I wanted to make work that privileges the material, formal, visual aspect of art-making and try to articulate the political through the aesthetics of the work. I like Gonzalez-Torres's attitude because his work is both aesthetic and political. What I admire most about his work is that it looks very simple, yet it deals with issues of vulnerability of the body, early death issues, etc., but does it all through the language of art.

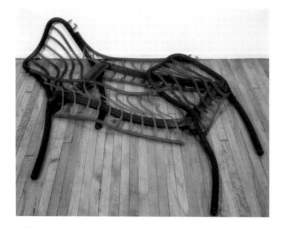

Marrow, 1996
Rubber, Dimensions variable, Photo: Orcutt and Van Der Putten

JA: So let's talk about "the body." We both get lumped into this category. Could you speak about the specific role of the body in your works? In a lot of your pieces the body is physically absent but implicitly present, or the body in question is really that of the viewer. I'm interested in the way you make the viewer feel physically in an installation or in front of an object.

MH: The body became an issue for me when I was a student in the late seventies at the Slade School, which is part of London University College. It was a very cool environment that favored intellectual inquiry. But I had this distinct feeling that people around me were like disembodied intellects. It was in opposition to this kind of attitude that I started focusing intensely on the body, first using its products and processes as material for the work, and later using it as a metaphor for society — the social body. Without

going into too much detail here, it seemed that anything I wanted to work with at the time was faced with restrictions and even censorship. I was perceived as this isolated incident, a person coming from nowhere and trying to disrupt a respectable intellectual environment. Those same issues that I was trying to discuss in my work at the time have become such common currency in the art world now — I mean in a very general sense, the focus on the body. By the late eighties I wanted to take my body, the body of the performer, out of the work. I wanted the viewer's body to replace mine by interacting directly with the work. My work is always constructed with the viewer in mind. The viewer is somehow implicated or even visually or psychologically entrapped in some of the installations. The sculptures based on furniture are very much about the body, too: they encourage the viewer to mentally project himself or herself onto the objects.

Divan Bed, 1996
Tread plate steel, 23.5" x 75" x 30"; Collection Tate Modern.
Photo: Edward Woodman

JA: There are two works that have epitomized the range from which you approach the body in your work — both bed pieces, which in the end somehow become the body. One is *Marrow*, which for me is a collapsed body. It is so moving because it brings me to the fragility of the body, or a kind of disappointment when the body has failed you. The fact that it is a collapsed crib also makes me think of a past that has imploded under its own weight. *Divan Bed*, a bed made out of cold steel, seems to be about the alienated body, a body grown uncomfortable with its own environment. Do you want to talk about that range?

MH: I called the first work *Marrow*, as in "bone marrow," but without the bone structure to support it. So as you say, it becomes the collapsed body. I used a honey-colored rubber that looks quite fleshy. In *Divan Bed*, I used tread-plate, which is an industrial flooring material. The distinctive raised pattern of the tread-plate is a cold, unyielding equivalent to the soft, quilted material that usually covers a divan bed . . . I was originally going to call the piece "Sarcophagus."

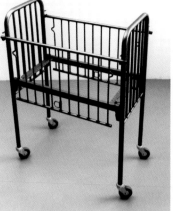

Incommunicado, 1993
Mild steel and wire, 49.75" x 22.5" x 36.5"
Collection Tate Modern
Photo: Edward Woodman

That gives you an idea of what I was thinking about.

JA: Both *Divan Bed* and *Marrow* are built in the same way that surrealist images are constructed.

MH: Yes, it makes me think of the paintings Magritte made where every surface in the painting — the person, the table, the window — everything has been chiseled out of rock. Also, Magritte's *Madame Récamier*, where the stiff-looking woman from David's painting has been replaced by a coffin lying on a chaise longue.

JA: Earlier we talked about whether people pick up these references and how most people are likely to talk more about everyday life. That piece has as much to do with Surrealism as it does with Minimalism. One would think that was a big leap in one work, but in the end they seamlessly come together. (*pause*)

MH: I like to use furniture in my work because it is about everyday life. Some of the objects are vaguely useful, but often they turn into uncanny objects. We usually expect furniture to be about

giving support and comfort to the body. If these objects become either unstable or threatening, they become a reference to our fragility. For instance, *Incommunicado* is an infant's hospital cot. It has been stripped to the bare metal, which makes it cold and harsh, and instead of having a solid base to support the mattress, there are thin wires that have been stretched across the frame. It looks more like an egg slicer, and you immediately associate it with a situation of danger and abuse. I called it *Incommunicado* to associate it with prisoners in solitary confinement. But also an infant in those situations has no ability to communicate about extremes of fear or pain.

JA: It's an interesting object, because it feels so cold. The minute you look at it and think of an egg slicer, it becomes incredibly visceral.

MH: When I started making these works, I was criticized for not showing the "spectacle of horror," but expecting the viewer to imagine for themselves the impending disaster. I personally felt that this was precisely the strength of the work and a sign of maturity in the way the work conjures up certain images in the viewer's mind. That these things are implied through the visual poetry of the work, rather than didactically stated, is much more satisfying for me.

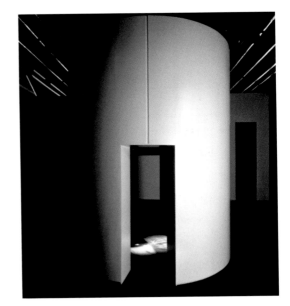

Corps étranger, 1994
Video installation with cylindrical wooden structure, video projector, amplifier, four speakers
138" x 118" x 118" Collection of Musée National d'Art Moderne, Centre Georges Pompidou, Paris Photo: Philippe Migeat

JA: I wonder whether it's something to do with the fact that people want you to act out for them, to do for them what they can't do themselves. I agree that it's much more interesting to have the viewer establish a relationship to the object and then analyze that response, as opposed to seeing you act out a relationship.

MH: I find work that obviously reveals itself, its intentions, so boring. It is about spoon-feeding people instead of treating them as intelligent and imaginative beings who could be challenged by the work.

JA: Why don't we talk about *Corps étranger*. First, what was it actually like to do the piece? Did it hurt? And second, what about the position of the camera as literally penetrating your body?

MH: The video was shot with the help of a doctor using an endoscopic camera. It didn't hurt at all. I was given a drug that seemed to dull the pain, but I remained completely conscious, and as my insides were being filmed, I was directing the video at the same time. I called it *Corps étranger*, which means "foreign body," because the camera is in a sense this alien device introduced from the outside. Also, it is about how we are closest to our body, and yet it is a foreign territory, which could, for instance, be consumed by disease long before we become aware of it. The "foreign body" also refers literally to the body of a foreigner. It is a complex work. It is both fascinating to follow the journey of the camera and quite disturbing. On one hand, you have the body of a woman projected onto the floor. You can walk all over it. It's debased, deconstructed, objectified. On the other hand, it's the fearsome body of the woman as constructed by society.

JA: It also swallows you. You go into the body, both in the image but also in the installation.

MH: Precisely. You enter the cylinder and you stand on the perimeter of the circular video image projected on the floor. You feel like you are at the edge of an abyss that threatens to engulf you. It activates all sorts of fears and insecurities about the devouring womb, the *vagina dentata*, the castration complex.

JA: In the end, was it important that it was your body?

MH: It had to be my body.

JA: In a weird way it's a kind of offering. It's an exposure. Did you feel invaded in any way?

Corps étranger, 1994
Photo: Philippe Migeat

MH: I wanted the work to be about the body probed, invaded, violated, deconstructed by the scientific eye. But when we were filming, I was too concerned about getting the right images for my video to connect personally with any of these feelings.

JA: What role does intuition play in your art?

MH: As I got more confident about my work, I started allowing myself to be more intuitive. One of the first and most intuitive decisions I made

was to make the video with my mother, *Measures of Distance*. At the time, it wasn't quite resolved in my head, but I decided to make it and worry about the consequences later. I was going against the grain of the current ideological discussion, but I'm so glad I made it.

JA: Does the work change very radically while you're making it, or do those decisions happen beforehand?

MH: There is a certain amount of decision making that happens beforehand. But as you probably know,

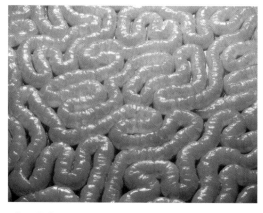

Entrails Carpet, 1995
Silicone rubber, 1.75" x 78" x 117"; Photo: Graydon Wood (detail)

being an artist yourself, when you start working with materials, they sometimes take you elsewhere, and one has to be open enough to make changes if something is not working out the way you conceived it on paper or conceptually. For instance, when I was making *Incommunicado*, I was originally going to connect safety pins together to make a grid that would replace the mattress support. I was going to call it something like "Safety Net." But when I started putting the pins together, it did not work visually. I felt that it looked too literal. Having put the bed together

without the platform, I loved that feeling of void in it. Somehow there was something wrong with activating that void too much. I wanted it to be much more subtle. I had already done an installation where I had stretched thin wire across a whole gallery space, and the wires were interrupting the body of the viewer in the main space at ankle level. When you got to the lower space the same wires hit you at the neck level. I wanted to rework that feeling of threat and dissection of the space into a more contained object, and of course because it is an infant's cot, it gives it a more psychological dimension.

JA: I find your objects to be stubborn in the best of ways. They are unyielding, conceptually tight, and formally imposing. They are what they are. It is your taste for the literal that I am most interested in. I want to talk about how you make meaning, and the fact that your meaning is in the object and not applied to it.

MH: I want the meaning to be embedded, so to speak, in the material that I'm using. I choose the material as an extension of the concept, or sometimes in opposition to it, to create a contradictory and paradoxical situation of attraction/ repulsion, fascination and revulsion. For instance, I intentionally used a very sensuous, translucent silicon rubber to make the *Entrails Carpet*. You want to walk all over it with bare feet. On the other hand, when you recognize the pattern on the surface of the carpet, you realize it's something very repulsive. It looks like entrails splayed out all over the floor, as if it's the aftermath of a massacre. There's a kind of attraction/repulsion operating here.

JA: When I was looking at your show at the New Museum, I thought of Eva Hesse and some of her poems and was wondering whether she is an influence.

MH: Eva Hesse was very much a model figure for my generation of women artists. She was around when Minimalism was happening, but her work was so much more organic and to do with the body. Someone once made a parallel between my *Socle du Monde* and the series of cubes Eva Hesse made, which she called *Accession*. As they said, my piece was like an inversion of the cubes she made with industrial material — perforated steel, where she inserted rubber tubes into the holes.

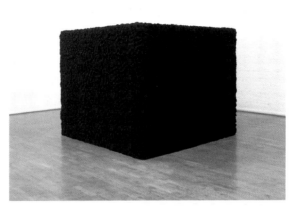

Socle du Monde, 1992-3
Wood structure, steel plates, magnets and iron filings
64.5" x 78.75" x 78.75"; Collection of the Art Gallery of Ontario, Toronto.
Photo: Edward Woodman

So on the inside, she created a furry surface. A quiet exterior and a tumultuous interior. In fact, when I made *Socle du Monde,* I wanted to use the cube, the Minimalist form par excellence, and turn it on its head, so to speak, by covering it with something that not only looks very organic, but is almost frightening because you don't immediately recognize what the texture is made of. Unlike the Minimalist cube that would have been made of perfectly machined surfaces, untouched by human hands.

JA: It's interesting because it feels very solid; the surface is very vulnerable. And, of course, you're dying to touch it. (*laughter*)

A year and a half ago we both spent a month at Sabbathday Lake, which is the only active Shaker

community left in the world. We lived with seven Shakers in a residency that was called "The Quiet in the Land." That's really where we got to know each other. How did the experience of living with the Shakers and their philosophy affect your work?

MH: There was such a beautiful, family-like feeling about the Shaker community, which activated all sorts of forgotten needs. They had taken us in as a part of their family, which I thought was very courageous of them, because who knows what artists are up to. There was a beautiful feeling of settledness and warm domesticity, which is in complete contrast with my nomadic existence. The work I made there happened very organically and ended up making reference to kitchen utensils and a kind of nostalgic domesticity. Being in this situation gave me permission to work with simple craft processes, maybe even reconnect with a gentle side of myself. I felt like working with my hands rather than constantly conceptualizing about the work before making it. The Shakers talk about "hands to work," which is quite nice — this kind of focusing all the time on the making. Being always occupied was a wonderful and sobering experience.

JA: The other half of that statement "hands to work" is "hearts to God."

MH: Oh, I forgot about that one. (*laughter*)

JA: How was it for you to be in these spiritual surroundings where that was really the focus of the making?

MH: Although this was the focus, it never came out in any kind of preaching. They are the perfect example of a truly spiritual community, which you experience in the way they conduct their ordinary everyday life without the dogma and the preaching. They show their beliefs by what they do, not what they say.

JA: It wasn't imposed upon us at all.

MH: Yes, I'm against organized religion, but that doesn't mean I'm not a spiritual person. It was only when I found myself living in the West that I started valuing the spiritual side of myself. Keeping hold of the spiritual side became quite a focus at one point. I got into meditation in order to compensate for the lack of spirituality around me.

This interview was previously published in *Bomb* Magazine, number 63, Spring 98.

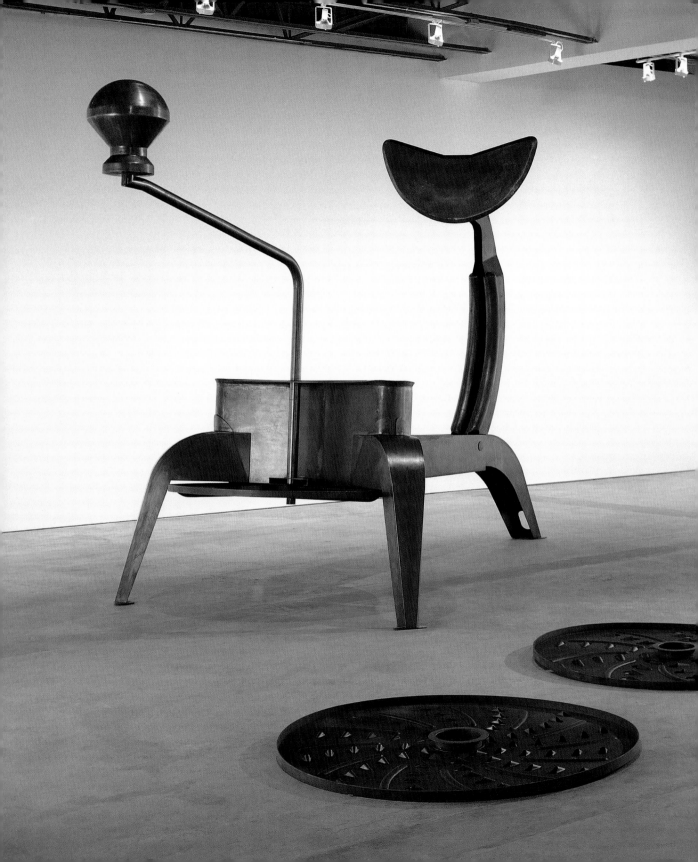

La Grande Broyeuse
(Mouli-Julienne x17), 1999
Mild steel
135" x 226.5" x 103.5"; disks 3" x 67" (diameter)
Courtesy of the artist and Alexander and Bonin, New York
Photo: Herbert Lotz, installation at SITE Santa Fe

La Grande Broyeuse
(Mouli-Julienne x17), 1999
Mild steel
135" x 226.5" x 103.5"; disks 3" x 67" (diameter)
Courtesy of the artist and Alexander and Bonin, New York
Photo (left): Herbert Lotz
Photo (right): Wim Van Nueten, installation at MUHKA,
Museum van Hedendaagse Kunst, Antwerp

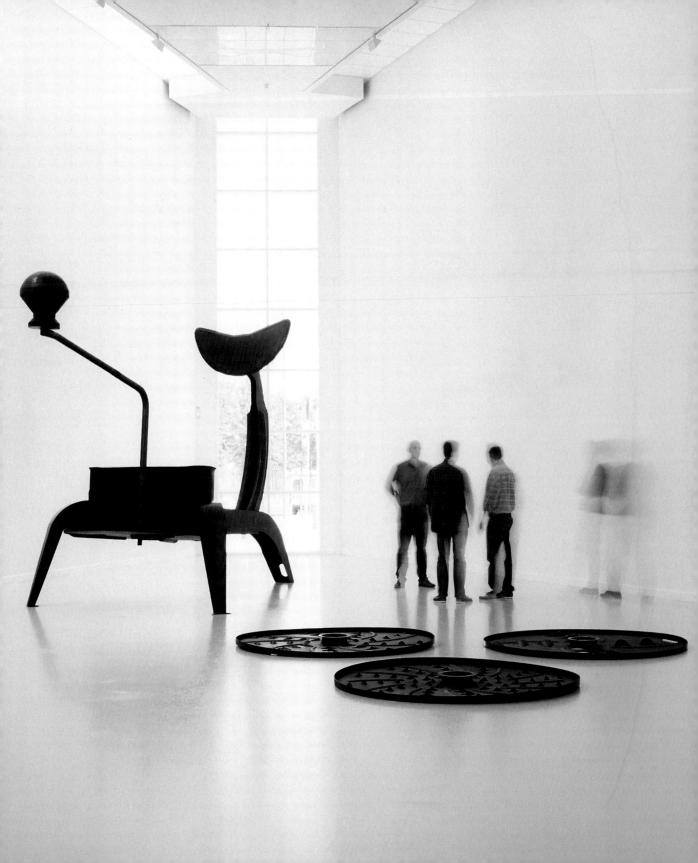

Slicer, 1999
Varnished steel and molded plastic
41" x 46" x 37"
Collection of Peggy and Ralph Burnet, Wayzata, Minnesota
Photo (left): Herbert Lotz
Photo (right): André Morin

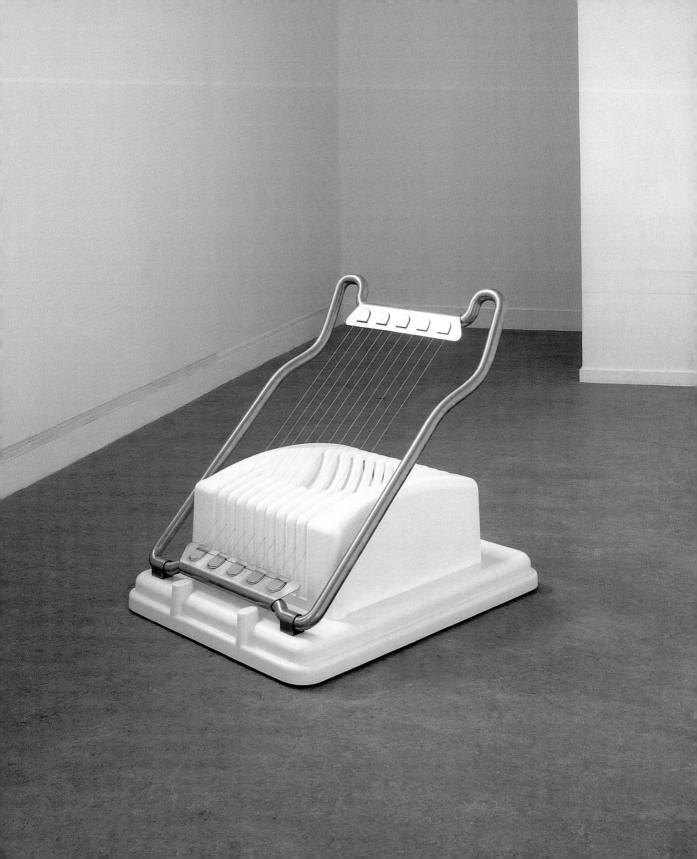

Le Creux de l'Enfer, 2000
Silver gelatin print
20" x 16"
Courtesy of the artist and Alexander and Bonin, New York

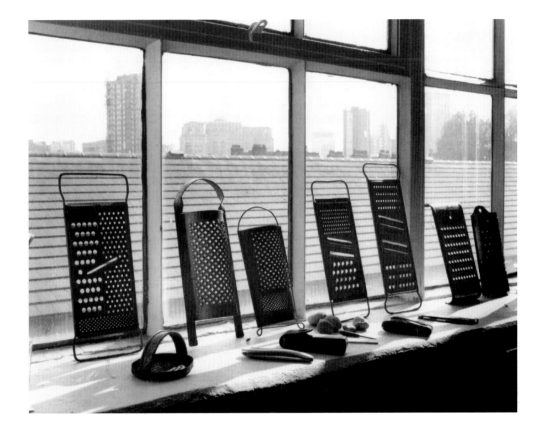

Untitled (graters), 1999
Silver gelatin print
16" x 20"
Courtesy of the artist and Alexander and Bonin, New York

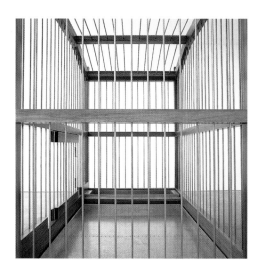

Untitled (Baalbeck birdcage), 1999
Wood, galvanized steel
122" x 117" x 77"
Courtesy of the artist and Alexander and Bonin, New York
Originally commissioned by ArtPace, a Foundation for
Contemporary Art, San Antonio
Photos: Herbert Lotz

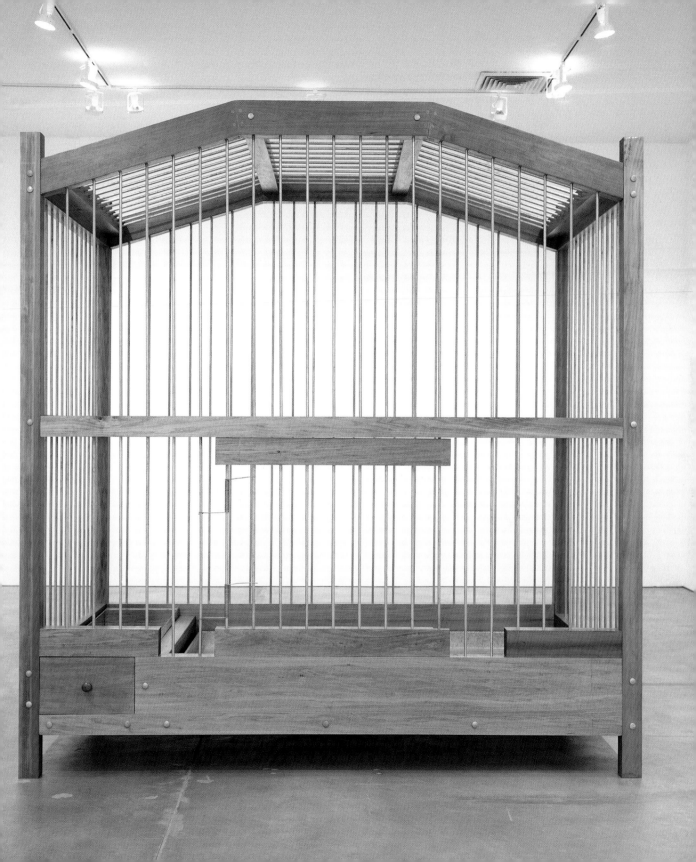

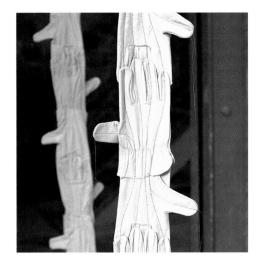

Chain, 1999
Leather gloves, nylon string, wood, and steel
39.5" x 10", height variable
Courtesy of the artist and Alexander and Bonin, New York
Photo (left): Joël Damase
Photo (right): Herbert Lotz

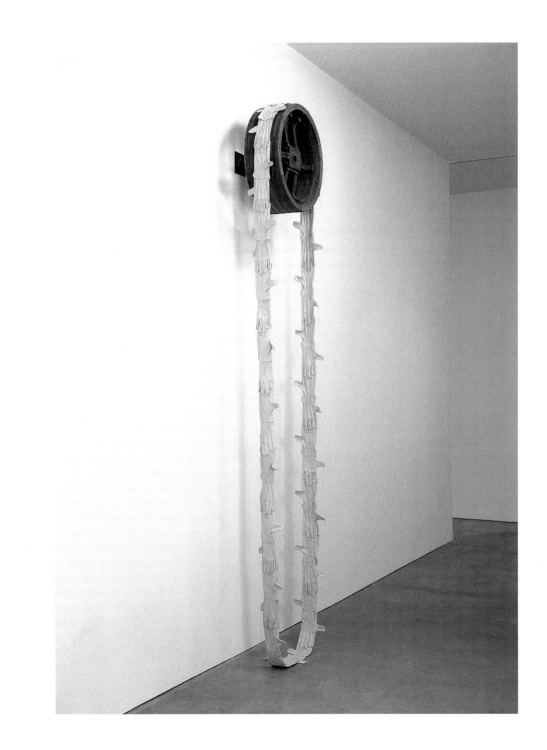

Vicious Circle, 1999
Glass bottles
3" x 69" (diameter)
Courtesy of the artist and Alexander and Bonin, New York
Photo: Herbert Lotz

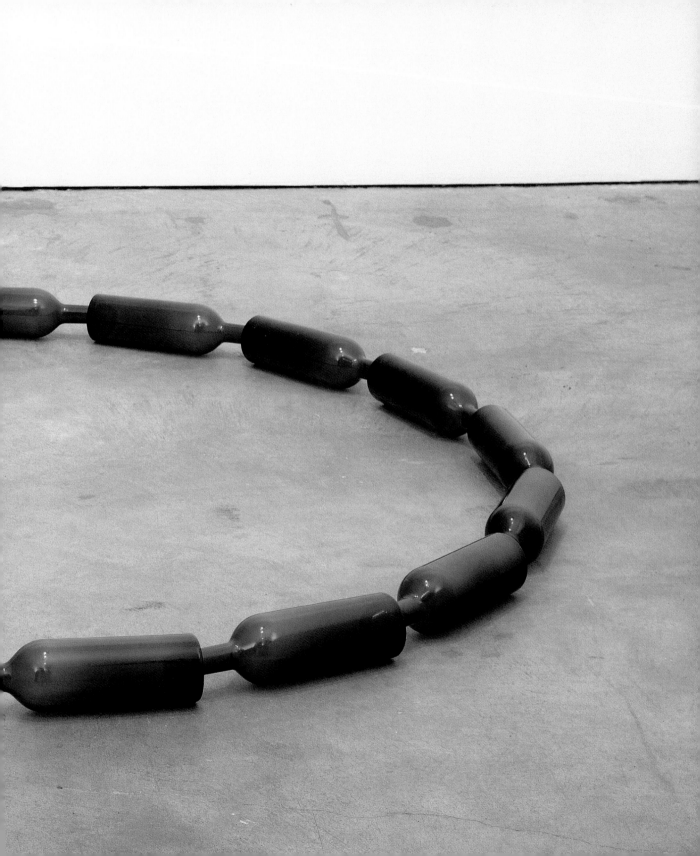

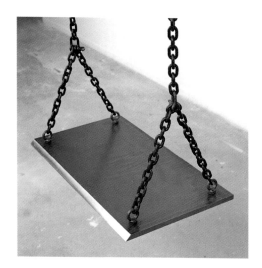

Balançoires en fer, 1999–2000
Mild steel
53.5" x 19.75"(installed), height variable
Marc and Livia Straus Family Collection, New York
Photos: Joël Damase, installation at Le Creux de l'Enfer, Thiers

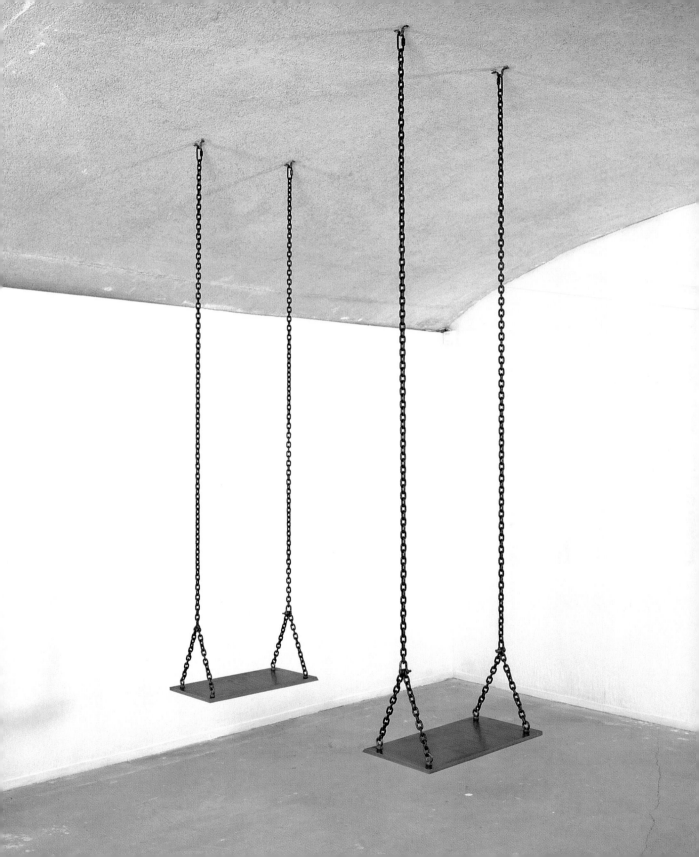

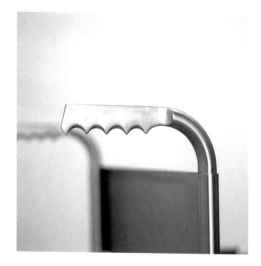

Untitled (wheelchair II), 1999
Stainless steel and rubber
37.25" x 19" x 25"
Collection of Lenore and Rich Niles, San Francisco
Photos: Herbert Lotz

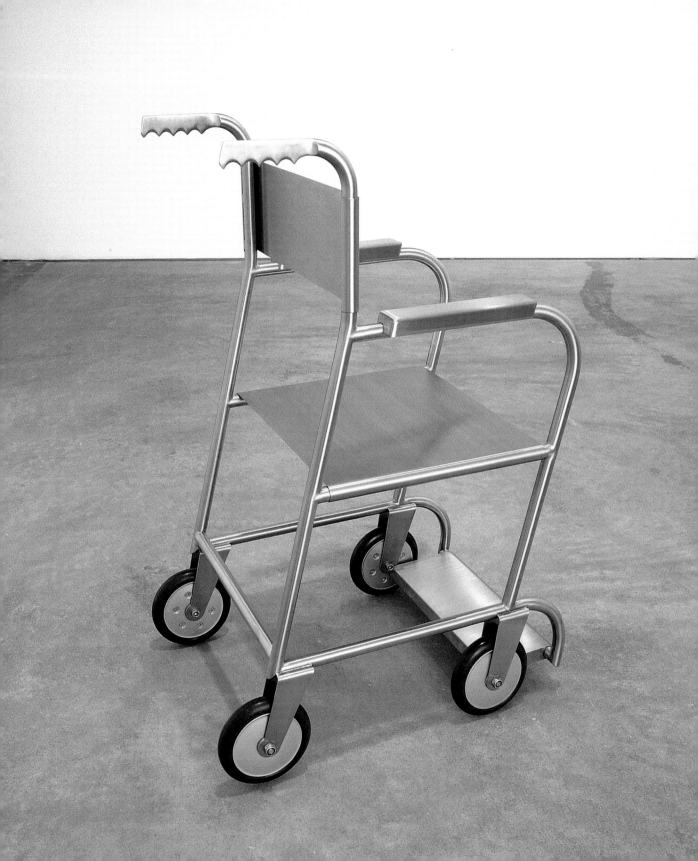

Home, 1999
Wood, galvanized steel, stainless steel, electric wire,
computerized dimmer switch, amplifier, speakers
Table: 30" x 78" x 29", overall dimensions variable.
Marc and Livia Straus Family Collection, New York.
Originally commissioned by ArtPace, a Foundation for
Contemporary Art, San Antonio
Photo: Orcutt and Van Der Putten

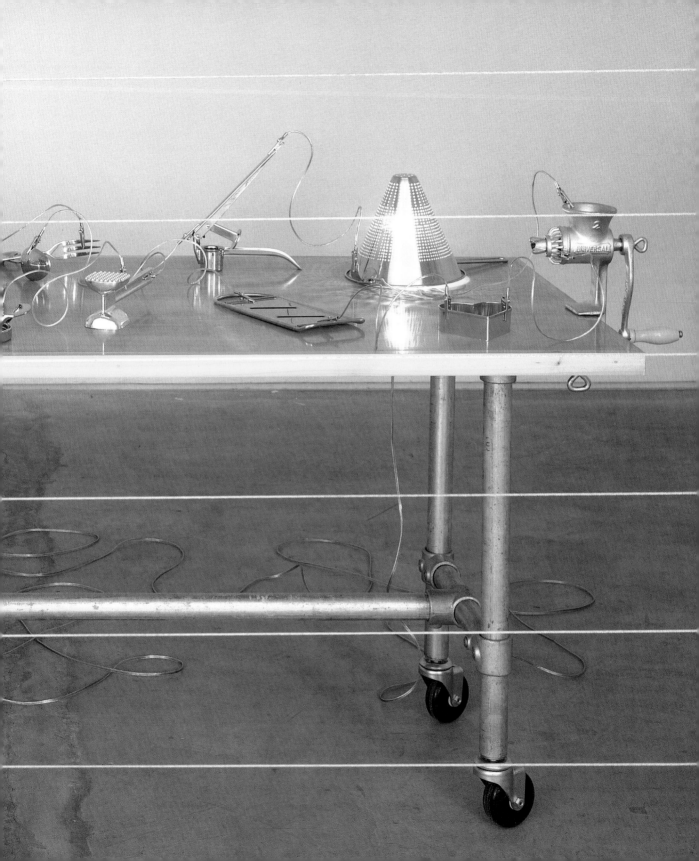

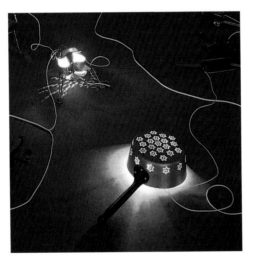

Sous Tension, 1999
Table, kitchen utensils, lightbulbs, electric wire,
computerized dimmer unit, amplifier, mixer, speakers
Dimensions variable
Courtesy of the artist and Alexander and Bonin, New York
Photos: Joël Damase, installation at Le Creux de l'Enfer, Thiers

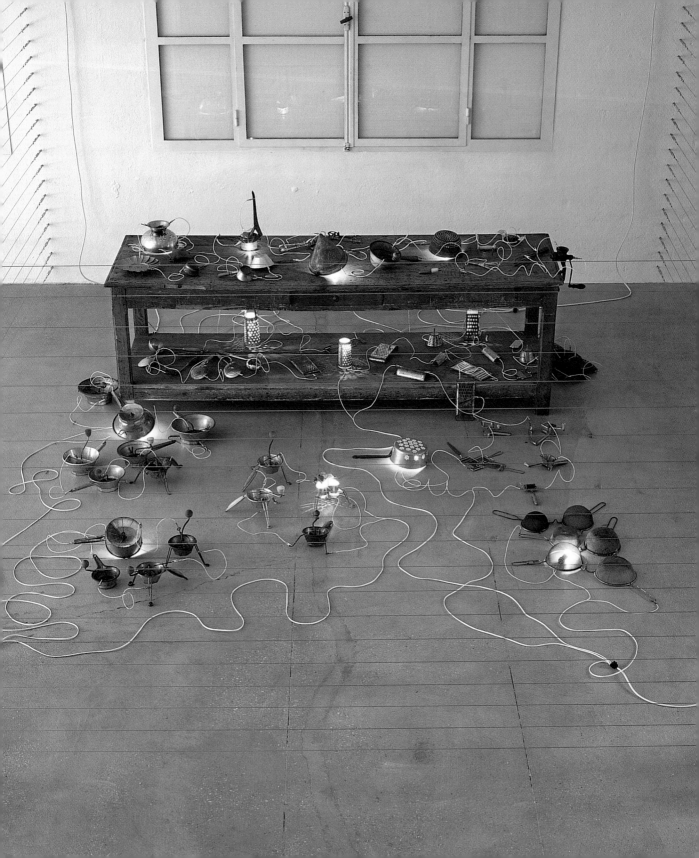

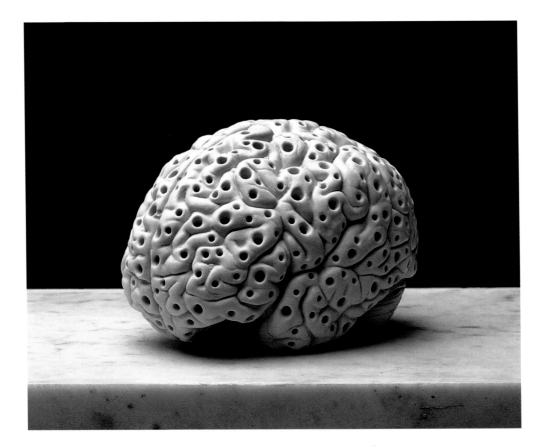

Untitled (brain), 1999
Silicone rubber
4" x 6.5" x 5"
Courtesy of the artist and Alexander and Bonin, New York
Photo: Will Brown

T42, 1993–98
Fine stoneware
2" x 9.5" x 5.5"
Courtesy of the artist and Alexander and Bonin, New York
Photo: Iain Dickens

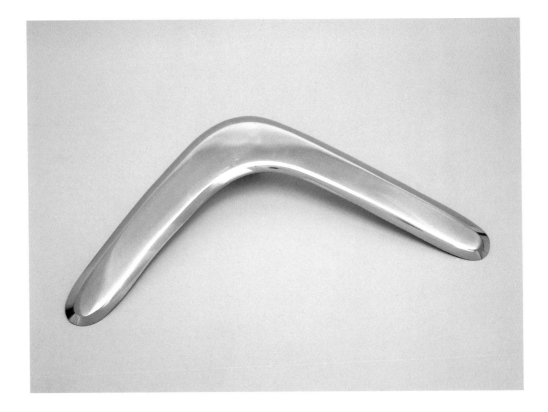

Do unto others..., 1997
Stainless steel
8.25" x 18.5" x .25"
Collection of the artist
Photo: Edward Woodman

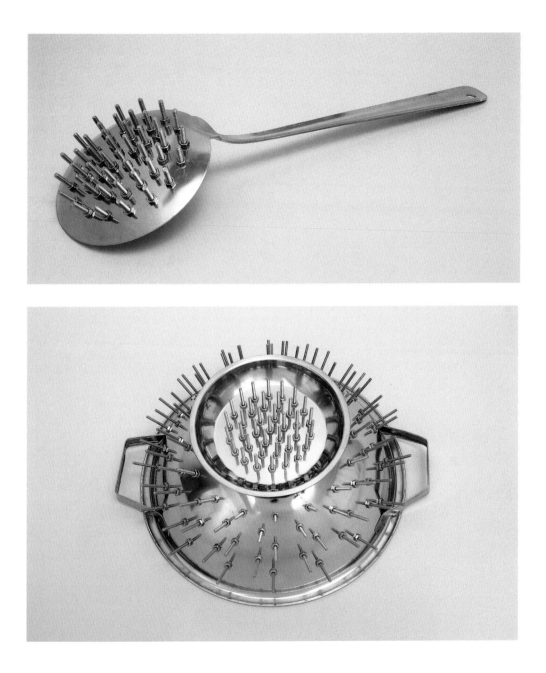

No way, 1996
Stainless steel
2.5" x 16" x 5"
Collection of the artist
Photo (top): Edward Woodman

No way III, 1996
Stainless steel
4.33" x 9.75" x 11.5"
Collection of the artist
Photo (bottom): Edward Woodman

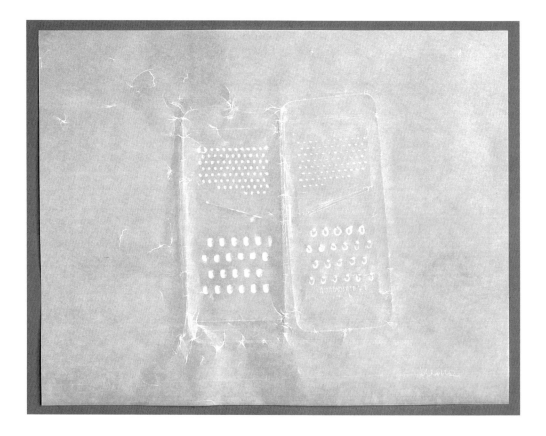

Sans titre (rape á fromage), 1999
Japanese wax paper
15" x 20"
Collection of the artist
Photo: Joël Damase

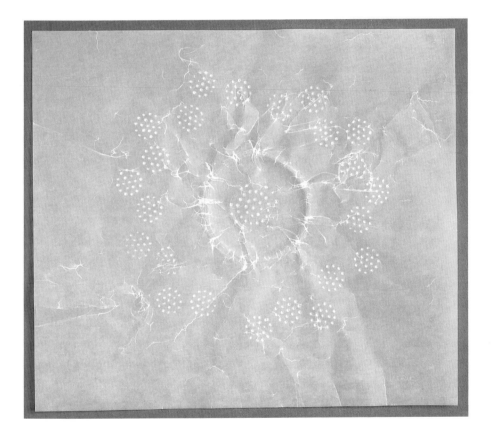

Sans titre (passoire de J–L), 1999
Japanese wax paper
17" x 19 "
Collection of the artist
Photo: Joël Damase

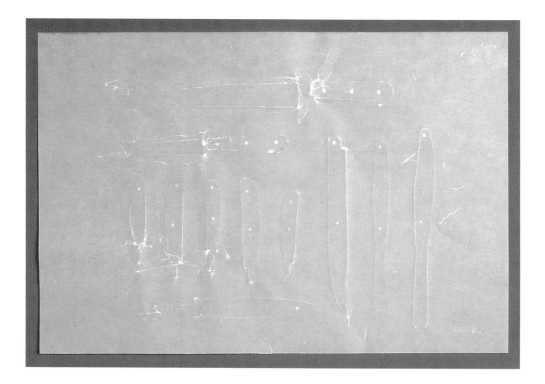

Sans titre (couteaux étalons thiernois), 1999
Japanese wax paper
14" x 21"
Collection of the artist
Photo: Joël Damase

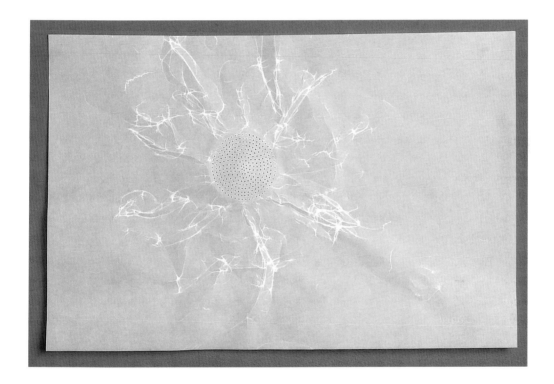

Sans titre (petite passoire a queue), 1999
Japanese wax paper
12" x 18 "
Collection of the artist
Photo: Joël Damase

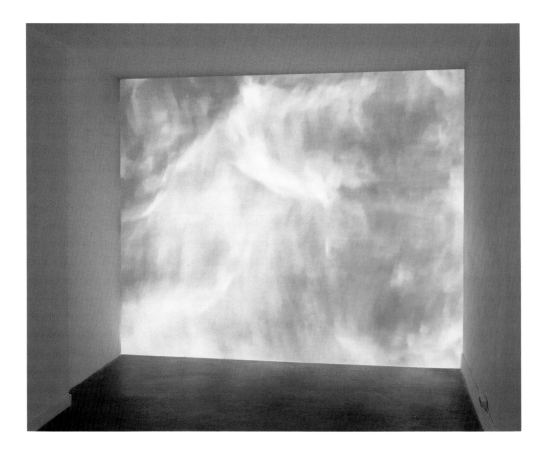

Vidéau, 1999
Video projection
Dimensions variable
Photo: André Morin

London, Summer 1999

Jo Glencross: The works you are planning for Le Creux de l'Enfer are mostly new works. Some of them seem quite sculptural, and at least three of the works are to do with kitchen utensils. Can you say something about where these references come from?

Mona Hatoum: Working with kitchen utensils continues my involvement with the everyday object — the assisted ready-made, turning into an uncanny, sometimes threatening, object. My first piece using a kitchen implement was a small work I made in Jerusalem in 1996 called *No way.* I used a ladle with holes — I think they call it a skimmer. I blocked all the holes using steel nuts and bolts, which of course negates its use, because there is *no way* through those holes. It also made it into something more like a weapon. Later on in the same year, I did a residency at a Shaker community in Maine where I made a number of works using kitchen utensils and things to do with cooking.

JG: You made a series of impressions on Japanese wax paper, didn't you?

MH: Yes, I used some beautiful old colanders and graters that had been handmade by members of the Shaker community in the 1880s. I also made another work by blocking the holes of a colander with nuts and bolts, which made it look like a land mine. Otherwise, I did some knitting and weaving with pasta, and I used castor sugar in another piece.

At the Shaker community there was a wonderful feeling of settledness, warm and nurturing domesticity. The stuff that real family homes are supposed to be made of. It made me realize how unsettled and nomadic and undomesticated my own existence is. I see kitchen utensils as exotic objects, and I often don't know what their proper use is. I respond to them as beautiful objects. Being raised in a culture where women have to be taught the art of cooking as part of the process of being primed for marriage, I had an antagonistic attitude toward all of that. Spending any time in the kitchen is something I resisted, along with learning to type, for instance. I didn't want to end up in a typing pool.

JG: What about this kitchen implement that looks like a praying mantis? It looks like an early food processor, is that right?

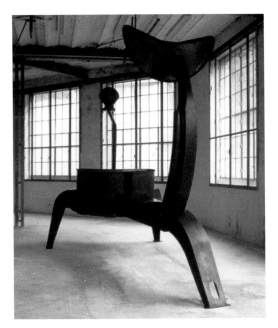

La Grande Broyeuse
(Mouli-Julienne x17), 1999
Mild steel, 135" x 226.5" x 103.5"
Photo: André Morin, Installation at Le Creux de l'Enfer, Thiers

MH: It's a rotary vegetable shredder called a Mouli-Julienne. It does look like a three-legged animal. It dates from the late 1940s or early 1950s. It's probably the first food processor invented after the Second World War. I think people in France are quite familiar with this. Isn't it a beautiful object?

JG: Yes, I was wondering whether you found it in an antique shop. Where does it come from?

MH: My mother never throws anything away.

I found it at the back of a cupboard while helping her clean up the kitchen during a visit to Beirut last summer. It's an object from my childhood.

JG: And what is the connection with Le Creux de l'Enfer?

MH: Thiers was and is still famous for the manufacturing of knives. The art center itself used to be a knife factory, and the river that runs along the side of the building was what provided the power to run all the machinery. Last autumn I read *La Ville Noire* by Georges Sand. It's a novel based on the lives of workers in Thiers. The dominant image I got was this sense of the whole place being about wheels, turning and grinding, and turning and grinding metal into thin cutting edges — until it all ground to a halt. So this is what inspired me to make a large Mouli-Julienne that looms over your head like a great big machine, with these large disks with multiple cutting and shredding edges.

JG: Having seen the enlarged maquette of this work, I can imagine a kind of transformative experience in the presence of this machine. The human scale of it gives the feeling that you've suddenly shrunk in size, rather like Alice in Wonderland, but there's also something menacing, because the body of the machine looks

like it could just about take a crouching person.

MH: Yes, there is very much this aspect of Alice in Wonderland. There is also an aspect of some kind of infernal machine, an instrument of torture. When I was proposing this work to Laurence Gateau, she said that it reminded her of a short story by Kafka, *In the Penal Colony* (*La colonie penitentière*). I reread the story after she mentioned it to me. It's about a mad commandant who invents a monstrous machine that administers the most cruel punishment. He calls it the Harrow, and it consists of a bed, where the person to be punished lies, and an arm that comes down and somehow carves directly on the body of the condemned the words of the sentence and in the process actually kills him.

JG: That's a very powerful image. How did you feel it related to the Mouli-Julienne?

MH: More structurally than anything else. The Mouli-Julienne has an arm that holds down the vegetable about to be shredded against the blade. But there is a sort of 'va et vient' that takes place when you're confronted with the large one. I imagine that when you first approach it, you're wondering what this huge contraption is. Then when you recognize it or make a connection with the kitchen implement, there is a moment of

relief, maybe even laughter. I think, this is then followed by feelings of dread, as you consider the scale of it and you realize its potential threat. I imagine that these feelings go back and forth.

JG: There's also a reference to the penitentiary in the work you've just made during the ArtPace residency in San Antonio. There, you also took something that is harmless — well, at least for human beings — and turned it into something that looks at the same time like both a four-poster bed and a prison cell.

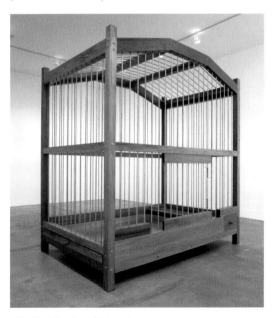

Untitled (Baalbeck birdcage), 1999
Wood, galvanized steel, 122" x 117" x 77.125"
Originally commissioned by ArtPace, a Foundation for Contemporary Art, San Antonio. Photo: Herbert Lotz

MH: The work you're referring to is based on a beautiful old birdcage, which I enlarged 10 times till it became as big as a room or a prison cell. In fact, when I was trying to decide on the final dimensions of this work *[Untitled (Baalbeck Birdcage)]*, I used the size of the prison cells in Alcatraz as a guide. In San Antonio, I also created a work that involved using an assemblage of kitchen utensils that were all connected together with electric wire. A buzzing, fluctuating electric current was driven through the objects to light up lightbulbs concealed under colanders and inside graters. It was both mesmerizing and lethal, because all the objects became live — electrified! I called it *Home*, because I see it as a work that shatters notions of the wholesomeness of the home environment, the household, and the domain where the feminine resides. Having always had an ambiguous relationship with notions of home, family, and the nurturing that is expected out of this situation, I often like to introduce a physical or psychological disturbance to contradict those expectations. For the exhibition in Thiers, I'm planning to elaborate on this idea and make a larger and maybe more industrial version of this work.

JG: The scale of many of your new works seems to have changed. Although you've worked with household objects or furniture before, they've grown in size. Why have you begun enlarging them?

MH: In the previous furniture or rug pieces, the scale remained the same as you'd expect, but the materials used made them into either fragile or macabre objects. In these new works, I'm using the scale as another way to turn the domestic into something menacing and all-engulfing.

JG: Looking at photos of Le Creux de l'Enfer, it seems like the sort of space that would inspire site-specific pieces, because of the many interesting features in it.

MH: The space in Thiers was very inspiring for me. It still has certain vestiges of its former use remaining in the space — like those wooden wheels attached to the ceiling on the ground floor. I'm making a work around one of those wheels, which would have had a leather belt around it. The river, which runs along the side of the building, and the waterfall are a quite dramatic part of the environment there. It is especially so in winter, when the water level is quite high and the river runs very fast. You hear the roaring sound of the water everywhere in the building, and the whole place is quite dank, especially since the

Untitled (wheelchair II), 1999
Stainless steel and rubber
37.25" x 19" x 25"
Collection of Lenore and Rich Niles, San Francisco

Balançoires en fer, 1999-2000
Mild steel
53.5" x 19.75" (installed), height variable
Marc and Livia Straus Family Collection, New York
(MASS MoCA only)

Chain, 1999
Leather gloves, nylon string, wood, and steel
39.5" x 10", height variable
Courtesy of the artist and Alexander and Bonin, New York

Vicious Circle, 1999
Glass bottles
3" x 69" (diameter)
Courtesy of the artist and Alexander and Bonin, New York

Vidéau, 1999
Video projection
Dimensions variable
(MASS MoCA only)

Untitled (graters), 1999
Silver gelatin print
16" x 20"
Courtesy of the artist and Alexander and Bonin, New York

Home, 1999
Wood, galvanized steel, stainless steel, electric wire,
computerized dimmer switch, amplifier, speakers
Table: 30" x 78" x 29", overall dimensions variable.
Marc and Livia Straus Family Collection, New York.
Originally commissioned by ArtPace, a Foundation for
Contemporary Art, San Antonio. (SITE Santa Fe only)

Le Creux de L'Enfer, 2000
Silver gelatin print
20" x 16"
Courtesy of the artist and Alexander and Bonin, New York

Untitled (panhandled colander), 2000
Japanese wax paper
17.25" x 22.5"
Courtesy of the artist and Alexander and Bonin, New York

Untitled (cylindrical grater), 2000
Japanese wax paper
15.75" x 21.5"
Courtesy of the artist and Alexander and Bonin, New York

Untitled (Thiers knives I), 2000
Japanese wax paper
10.75" x 14.5"
Courtesy of the artist and Alexander and Bonin, New York
(MASS MoCA only)

Untitled (Thiers knives II), 2000
Japanese wax paper
14" x 19.75"
Courtesy of the artist and Alexander and Bonin, New York
(MASS MoCA only)

Untitled (Thiers knives III), 2000
Japanese wax paper
16" x 21.5"
Courtesy of the artist and Alexander and Bonin, New York
(MASS MoCA only)

Mona Hatoum is making four new works,
currently untitled, for this exhibition.

Biography

1952 Born Beirut, Lebanon

1970-1972 Beirut University College, Beirut

1975-1979 The Byam Shaw School of Art, London

1979-1981 The Slade School of Art, London

Living and working in London since 1975

Solo exhibitions (since 1989)

1989 *The Light at the End*, The Showroom, London
The Light at the End, Oboro Gallery, Montréal

1992 *Mona Hatoum*, Mario Flecha Gallery, London
Dissected Space, Chapter, Cardiff

1993 *Recent Work*, Arnolfini, Bristol
Le Socle du Monde, Galerie Chantal Crousel,
Paris

1994 *Mona Hatoum*, Galerie René Blouin, Montréal
Mona Hatoum, Musée national d'art moderne,
Centre Georges Pompidou, Paris
Mona Hatoum, C.R.G. Art Incorporated, NY

1995 *Mona Hatoum*, White Cube, London
Short Space, Galerie Chantal Crousel, Paris
Mona Hatoum, The British School at Rome

1996 *Mona Hatoum*, The Fabric Workshop and
Museum, Philadelphia
Mona Hatoum, Anadiel Gallery, Jerusalem
Current Disturbance, Capp Street Project,
San Francisco
Quarters, Via Farini, Milan
Mona Hatoum, De Appel, Amsterdam

1997 *Mona Hatoum*, Museum of Contemporary Art,
Chicago and The New Museum of
Contemporary Art, New York
Mona Hatoum, Galerie René Blouin, Montréal

1998 *Mona Hatoum*, Museum of Modern Art, Oxford
and the Scottish National Gallery of Modern Art,
Edinburgh
Mona Hatoum, Kunsthalle Basel

1999 *Mona Hatoum*, Castello di Rivoli, Museo d'Arte
Contemporanea, Turin
Mona Hatoum, The Box, Turin
Mona Hatoum, ArtPace, A Foundation for
Contemporary Art San Antonio, Texas
Mona Hatoum, Le Creux de l'Enfer,
Centre d'art contemporain, Thiers, France
Mona Hatoum, Alexander and Bonin, NY

2000 *Mona Hatoum*, Le Collége, Frac Champagne-Ardenne, Reims, France and MUHKA, Museum van Hedendaagse Kunst in Antwerpen 2000

Mona Hatoum, The Entire World as a Foreign Land, Duveen Galleries, Tate Britain, London

Images from Elsewhere, fig-1, London

Mona Hatoum, SITE Santa Fe, Santa Fe, New Mexico

Publications

Mona Hatoum, Arnolfini, Bristol, 1993 (texts Guy Brett and Desa Philippi)

Mona Hatoum, Musée national d'art moderne, Centre Georges Pompidou, Paris, 1994 (texts Jacinto Lageira, Desa Philippi, Nadia Tazi, and Christine van Assche)

Mona Hatoum, De Appel, Amsterdam 1996 (text Din Pieters)

Mona Hatoum, Contemporary Artists series, Phaidon Press, London 1997 (texts Michael Archer, Guy Brett, and Catherine de Zegher)

Mona Hatoum, Museum of Contemporary Art, Chicago 1997 (texts Jessica Morgan and Dan Cameron)

Mona Hatoum, Kunsthalle Basel, Basel 1998 (texts Madeleine Schuppli and Briony Fer)

Mona Hatoum, Castello di Rivoli, Museo d'Arte Contemporanea, Torino, Edizioni Charta, Milano 1999 (text Giorgio Verzotti)

Mona Hatoum, The Entire World as a Foreign Land, Tate Gallery, London 2000 (texts Edward Said and Sheena Wagstaff)

Mona Hatoum, Le Creux de l'Enfer, Centre d'art contemporain, Thiers; Le Collége Éditions, Frac Champagne-Ardenne, Reims; MUHKA, Museum van Hedendaagse Kunst in Antwerpen 2000 (text Jean-Charles Masséra)